The O'Reilly Animals

AN ADULT COLORING BOOK

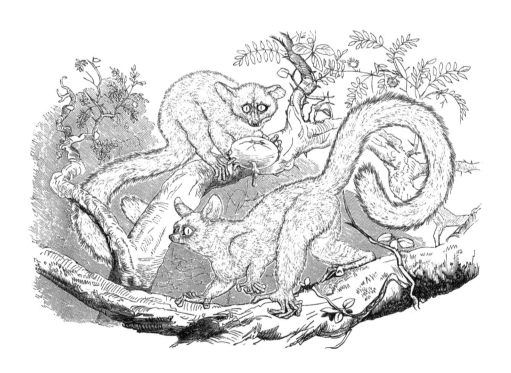

O'REILLY®

Many of the animal engravings that appear on O'Reilly Animal books are from illustrated 18th and 19th century books on natural history, including Richard Lydekker's *Royal Natural History* (1893); Reverend J. G. Wood's *Animate Creation* (1898), *Insects Abroad* (1883), and *Illustrated Natural History* (1862); *Riverside Natural History* (1884); *Meyers Kleines Lexicon* (1894), and the *Brockhaus Lexicon* (1882).

The images in this coloring book have been adapted from the original engravings by Karen Montgomery.

TOUCA

from *Meyers Kleines Lexicon*, 18

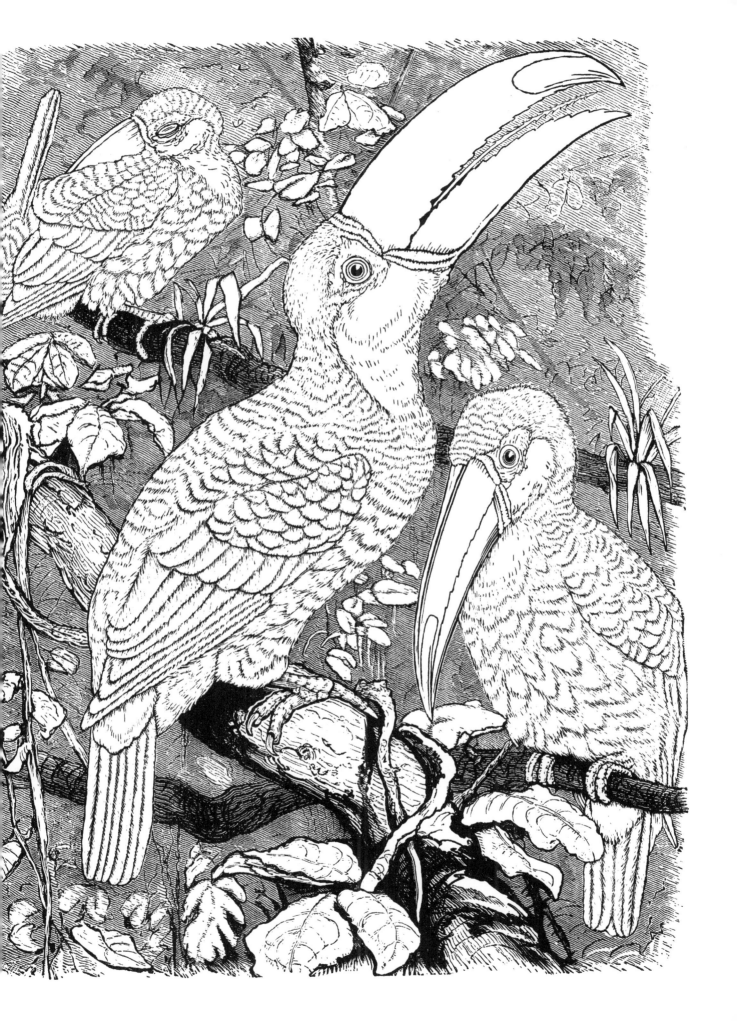

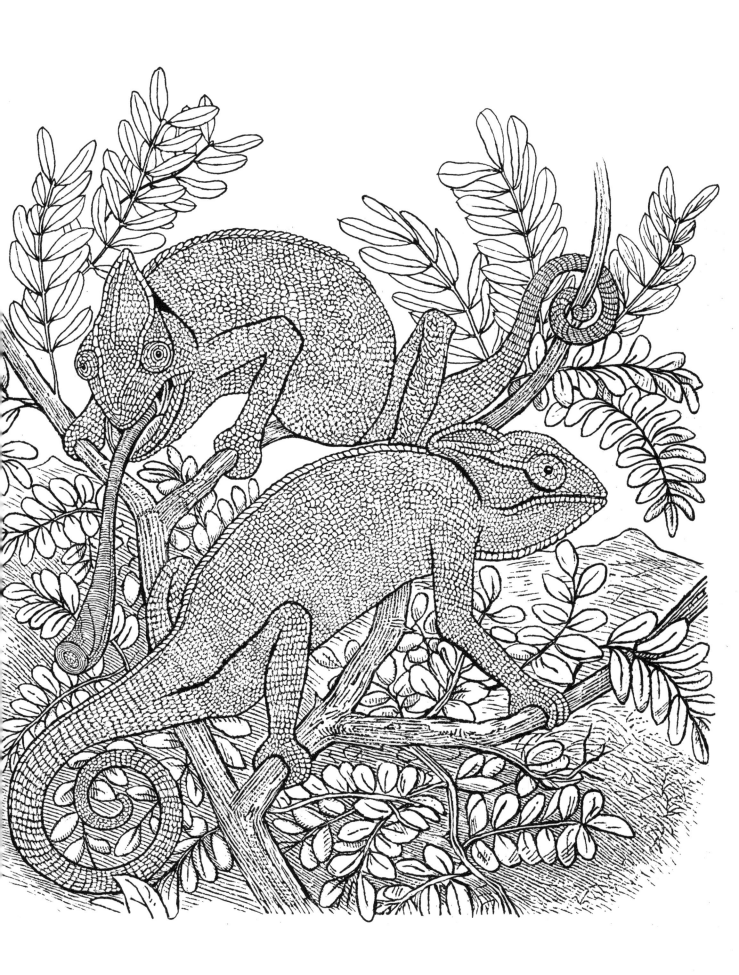

BANDED ARCHERFISH & SCRAWLED BUTTERFLY FI

from *Brockhaus Lexicon,*

FANFOOT GECK

from Richard Lydekker's *Royal Natural History*, 18

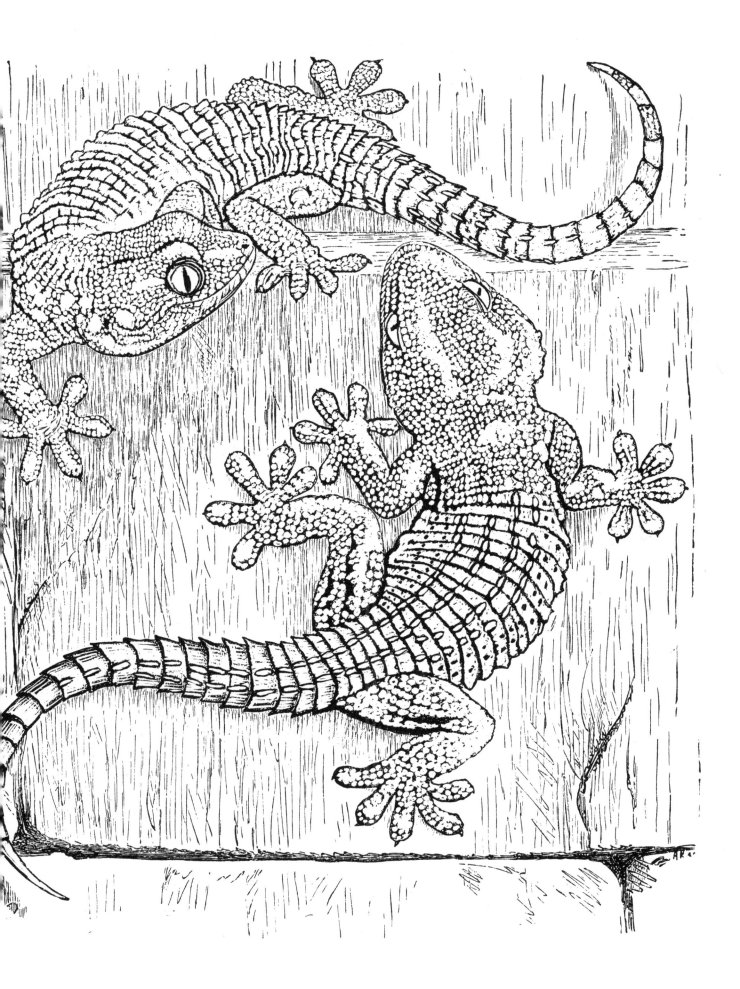

SEA CREATUR

from *Meyers Kleines Lexicon*, 1

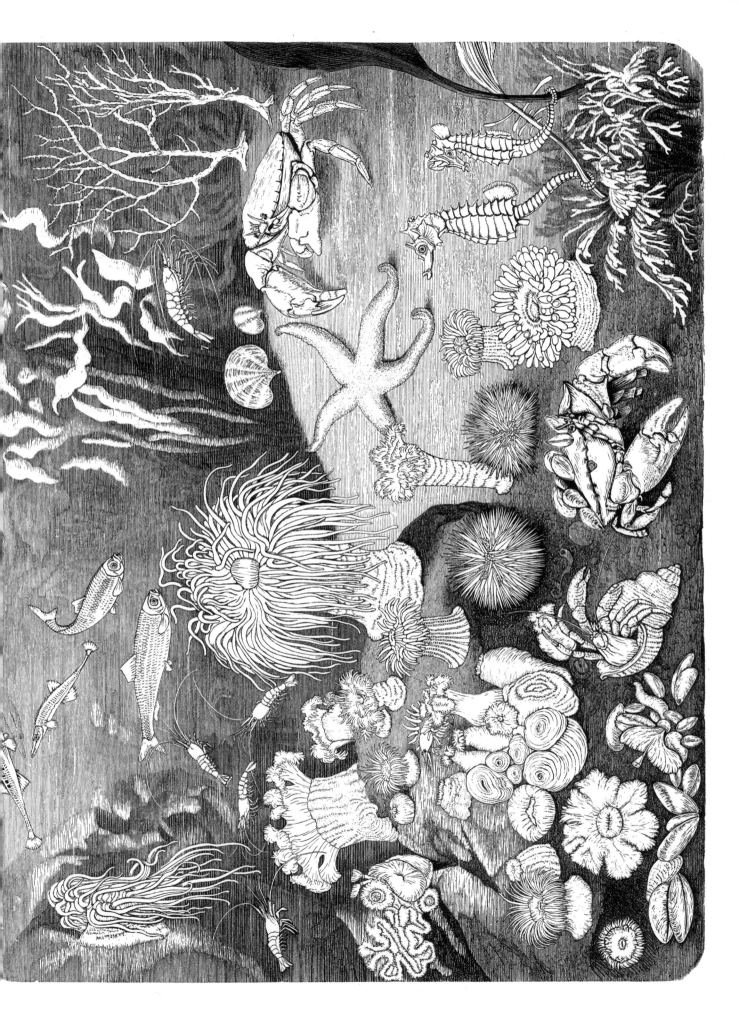

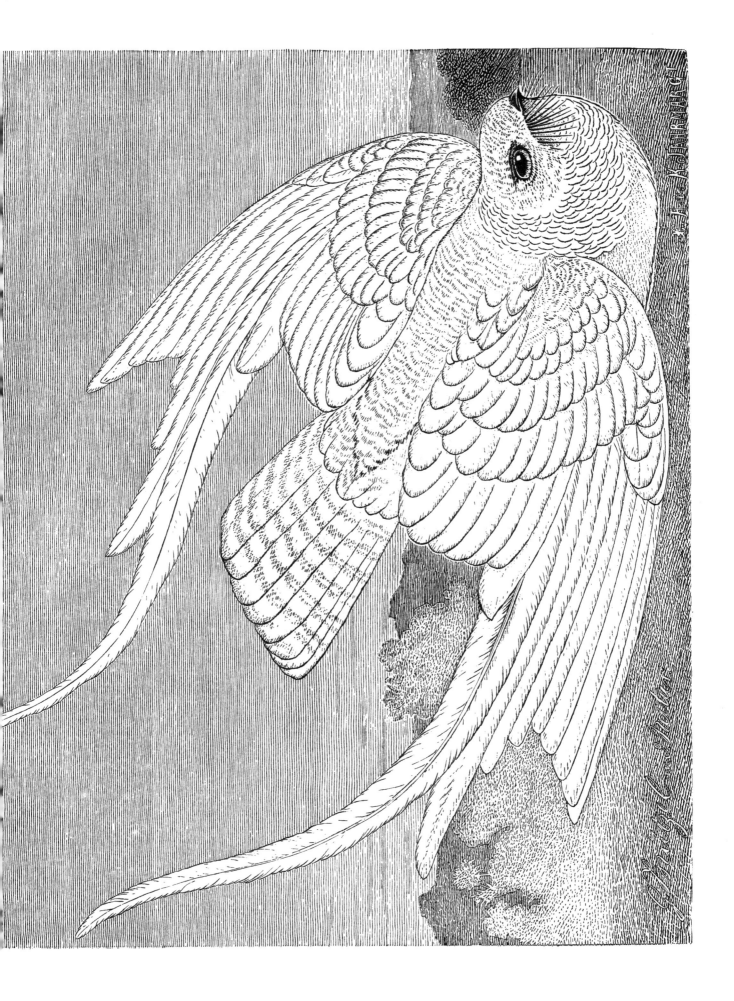

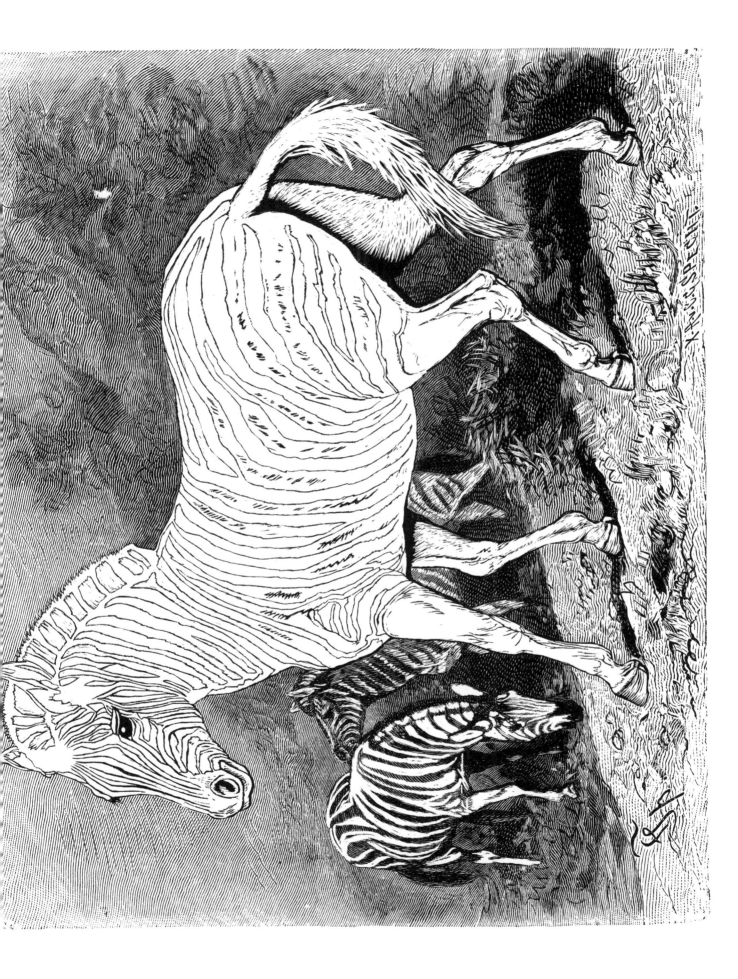

RAJAH BROOKE'S BIRDWING & RIPPON'S BIRDWI

from Rev. J.. G. Wood's *Insects Abroad*, 18

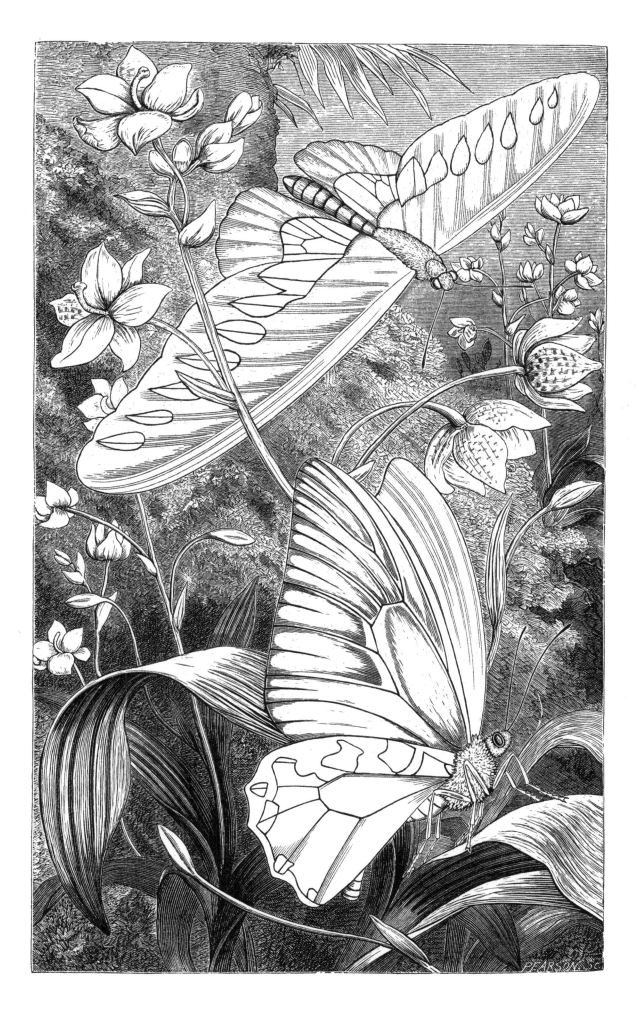

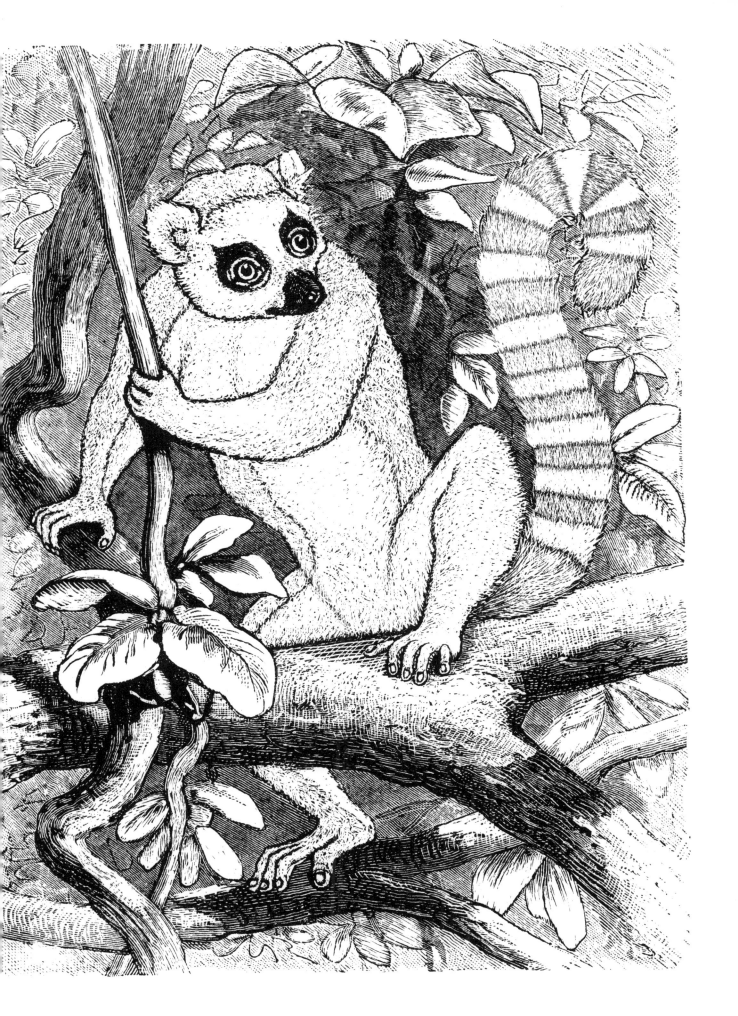